STARING
BACK

On Picasso's *Demoiselles d'Avignon*

STARING BACK

On Picasso's *Demoiselles d'Avignon*

ESSAYS BY

Laura Blereau

Janie Cohen

Beth S. Gersh-Nešić

Fleming Museum of Art | University of Vermont | Burlington | Vermont

This catalogue is published by the Fleming Museum of Art, University of Vermont, Burlington, and distributed by University Press of New England, One Court Street, Lebanon, NH 03766. www.upne.com

STARING BACK: THE CREATION AND LEGACY OF PICASSO'S *DEMOISELLES D'AVIGNON*
Fleming Museum of Art
February 3 – June 21, 2015

The exhibition, catalogue, and related programs have been funded, in part, by the Kalkin Family Exhibitions Endowment Fund; the Walter Cerf Exhibitions Fund; Rolf Kielman and Stephanie Spencer; TruexCullins Architecture and Interior Design; Kimberley Adams, M.D., and Mark Depman, M.D.; Brianne Chase '62; Neil and Ursula Owre Masterson '89; the Offices of the President and the Provost at the University of Vermont; and Lillian and Billy Mauer through the Fleming Contemporary Art Fund.

Fleming Museum of Art, University of Vermont
61 Colchester Avenue
Burlington, Vermont 05405
(802) 656-0750
www.flemingmuseum.org

© 2015 Fleming Museum of Art

Edited by Janie Cohen, Fleming Museum of Art
Catalogue Design: Chris Dissinger, Fleming Museum of Art

ISBN 0-934658-13-7

Printed by Villanti Printers, Milton, Vermont

COVER IMAGE:
Leonce Raphael Agbodjélou (Beninese)
Untitled (Demoiselles de Porto Novo), 2012
C-Print
59 x 39 in.
Courtesy of Jack Bell Gallery, London

CONTENTS

Staring Back examines Picasso's creative process of seeking inspiration in the art of the past. It tracks new generations of artists as they look back at Picasso's game-changing painting. And it looks hard at *Les Demoiselles d'Avignon* as it stares back at us, still elusive, ever challenging.

This exhibition began as a challenge: was it possible to organize a focus exhibition on this major painting, *without* the painting. Since its arrival at the Museum of Modern Art in 1939, Picasso's *Les Demoiselles d'Avignon* has left the Museum only once – in 1988 to travel to Paris and Barcelona for a comprehensive exhibition of the work and many of its preparatory paintings and drawings. Having published on Picasso over the years, and recently engaged in new research on *Demoiselles,* I was attracted by the challenge. This fascinating and vexing painting tells the story of Picasso's creative process and ongoing influence better than any other. It was a turning point for the ambitious 25-year-old artist and, ultimately, for the course of Western art.

The academic museum has a mandate to experiment, push boundaries, explore critical perspectives, and take chances. To engage this project, we would need creative collaborators, ideally, who include software in their tool kits. Working with technology through the perspective of artists, we could better navigate the dangers of both didacticism and spectacle. We found partners in Coberlin Brownell, a designer and visual artist, and Jenn Karson, a sound artist; both are University of Vermont (UVM) alumni and artist/educators. We invited them to bring their creativity and technological expertise to bear on the exhibition, to propose strategies, technologies, and participatory components.

Interwoven through the gallery spaces are a film short, sound and video installations, digital projections, augmented reality, and motion computing, creating an environment that merges new genre installations with exhibition design and interpretation. The exhibition illuminates Picasso's use of art historical and visual culture sources in the creation of *Demoiselles,* his studio process, and the extreme arc in the reception of the painting: from initial derision and outrage to its position today as a cornerstone of Modern Art. Work in a range of mediums by contemporary artists in Africa, America, and Europe, contribute feminist and post-colonial perspectives on *Demoiselles,* among other approaches, responding directly to the painting over 100 years after its creation. Finally, this catalogue extends the experimental spirit of the exhibition, offering historical fiction, as well as art historical and critical writing.

Staring Back has been an exhilarating collaboration. The Fleming Museum took this project from conception to realization with a curatorial team that included Coberlin Brownell, Assistant Professor, Emergent Media Program at Champlain College, Burlington, Vermont; Jenn Karson, Sound Artist; Lecturer, UVM College of Engineering and Mathematical Sciences; the Fleming's Exhibition Designer and Preparator, Jeff Falsgraf; and our Manager of Collections and Exhibitions, Margaret Tamulonis. Together this group tackled all facets of the project, from conceptual and theoretical, to logistical and experiential. Cornelia Clay '15, curatorial intern extraordinaire, contributed to the curation of the contemporary work responding to *Demoiselles*.

We are grateful for the generous financial support that has been provided by the Kalkin Family Exhibitions Endowment Fund; the Walter Cerf Exhibitions Fund; Rolf Kielman and Stephanie Spencer; TruexCullins Architecture and Interior Design; Kimberley Adams, M.D., and Mark Depman, M.D.; Brianne Chase '62; Neil and Ursula Owre Masterson '89; the Offices of the President and the Provost at the University of Vermont; and Lillian and Billy Mauer through the Fleming Contemporary Art Fund.

Thanks to the following for lending their time, energy, and voices for the sound work *The Picture Was an Outrage*: DJ Hellerman, Curator, Burlington City Arts; Major Jackson, Richard Dennis Green and Gold Professor Professor, Department of English, UVM; Allison Nobile '15; Angela Patten, Senior Lecturer, Department of English, UVM; David V. Rosowsky, Provost and Vice President, UVM; Barbara Zucker, Professor Emerita, Department of Art, UVM; and to Joe Egan and Egan Media Productions. Thanks to Andrew Giroux '15 and to Alan Mosser of UVM's Department of Theatre for their help with the film short *Picasso at 23*.

Our enormous gratitude to the artists and lenders to the exhibition, and to Damian Elwes for his generous loan of the digital image of *Picasso's Studio at the Bateau Lavoir, 1908* for use in the video projection *Picasso's Studio*.

My personal thanks to UVM colleagues and friends Mary Jane Dickerson, Moustapha Diouf, John Gennari, Sumru Tekin, and Barbara Zucker, and to the Vermont Studio Center.

JANIE COHEN
Director, Fleming Museum of Art
University of Vermont, Burlington

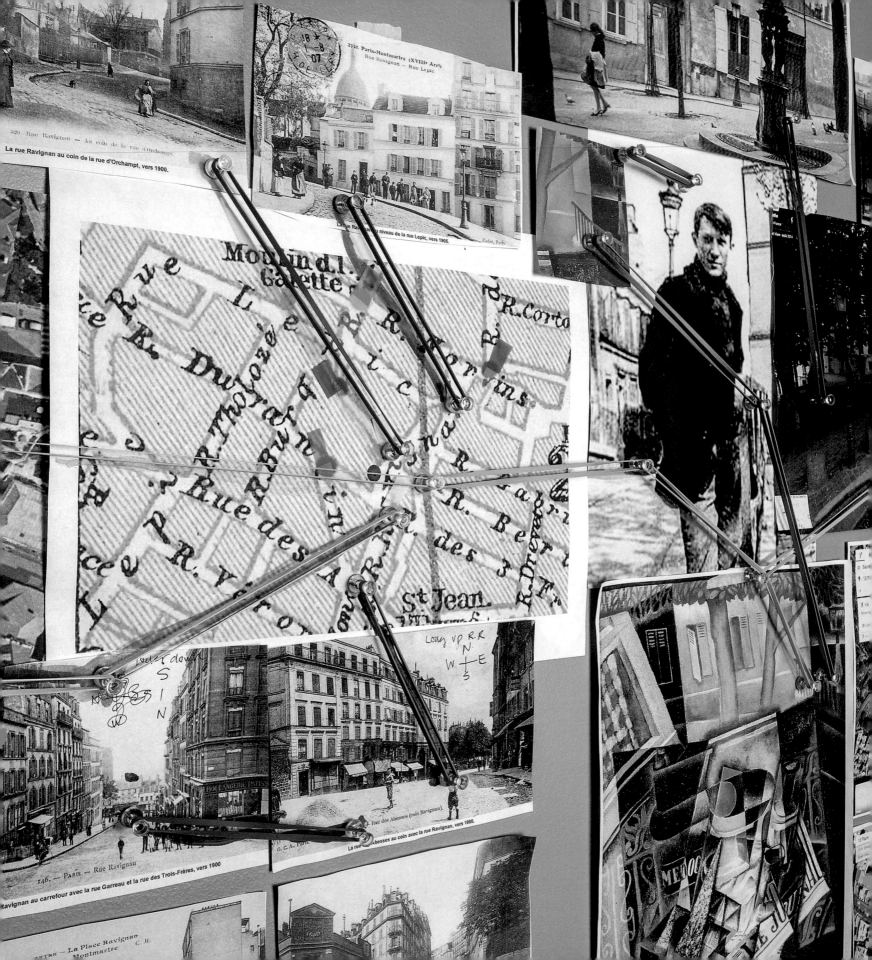

The Technological Avant-Garde and the Museum

BY LAURA BLEREAU

INTRODUCTION

The innovative works of two Vermont artists, Jenn Karson and Coberlin Brownell, are positioned at the forefront of *Staring Back: The Creation and Legacy of Picasso's* Demoiselles d'Avignon. In the exhibition, these pieces project sound and light; interaction with the viewer is staged in zones that operate sonically, as well as haptically. They set a tone of artistic experimentation that the exhibition, as a whole, champions in its examination of Picasso's creative process for his groundbreaking 1907 painting.

Picasso's radical break with the tradition of handling perspective can be understood as a key precedent to the techniques of computer vision and virtual representation. The visual daring contained in artworks based in multiple-point perspective is inherently systematic and technological. Fracture of the human figure and picture plane is tied to the emergent conceptualism of Picasso's day, and the direct gaze of his five figures even suggests some level of interactivity. However, an artist's "frame" today has moved well beyond painting; it can be time-based, split-screen, flat, participatory, generative, sculptural, or entirely virtual.

The pieces by Karson and Brownell forge an understanding of Picasso's working method, and seamlessly incorporate information related to his studio practice while he was painting *Demoiselles*. As authors, they have gone beyond creating stunning works of art that stand on their own as contemporary objects. The experience of their installations is both instructive and spectacular. Here, the dialogue between art and technology is equally strategic and poetic; it generates ideas about the initial shock of Picasso's painting, as well as the contemporary notions of the archive and global networks.

Left:

Detail of soundscape studies, Jenn Karson's studio.

JENN KARSON

Karson's contributions include two site-specific installations, and one short film collaboration with Coberlin Brownell. In the process of creating these works, she staged and produced recordings, and also captured existing sounds online, using sites such as Google, Sounddogs, Wikipedia, and YouTube. Her vision is achieved through a broad sense of perspective, and executed in a manner similar to movie directors working with actors, editors, and sound effects. Karson's handling of sound is also influenced by the tradition of *musique concréte*, which relies on the apparatus of reproduction, as well as incorporating generative compositional techniques using live software playback.

Located at the exhibition's entrance, *Place Ravignan* features an audio collage housed by a vintage Cygnet horn from the Edison Fireside Phonograph. Appearing worn and weathered, this sculpture plays with our expectations of early 20th-century artifacts and the simulated presence transmitted by an audio recording. The piece depicts the physical environment that birthed Cubism and served as home to a number of luminaries of the Modernist art and literary movements. It crafts a soundscape that evokes the surroundings of *Le Bateau Lavoir*, Picasso's studio in 1907, where *Les Demoiselles d'Avignon* was painted.

Place Ravignan imagines a walk from Picasso's studio through the bohemian neighborhood of Montmartre. The composition is named after a small cobblestone square that faces *Le Bateau Lavoir* and it maps out a narrative based on incidental noises, or "found" sounds. The building was known for its dark, drafty interior and creaky floorboards, so much so that it was nicknamed for the laundry boats anchored in the Seine. In Karson's collage we hear the warm crackling of a coal stove, cries from Minou (Picasso's cat), steps in the hallway, a knock at the door, and the bells of Sacré-Coeur Basilica. Trotting horses and the roar of early motorcars are detected, as we mentally travel past Le Chat Noir and famed cafés, filled with lively chatter. A distorted mix of Erik Satie's music floats through the neighborhood, punctuated by the restless murmurs of pigeons. Clinking wine glasses and dishes are heard, while a crowd's laughter and banter intensifies.

As a vessel, the sound sculpture evokes composers such as John Cage, Annea Lockwood, and Stephen Vitiello, as it transports viewers from an interior space, inside Picasso's studio, to that of the public and outdoors—essentially a space of social engagement. Karson's idea of place in this work is based on a virtual and idealized site that is informed by historical and contemporary research. In this process, she consulted Google maps, a 1900 edition of the travel book *Baedeker's Paris and its Environs*, and *Loving Picasso*—the journal of Fernande Olivier. Picasso's mistress

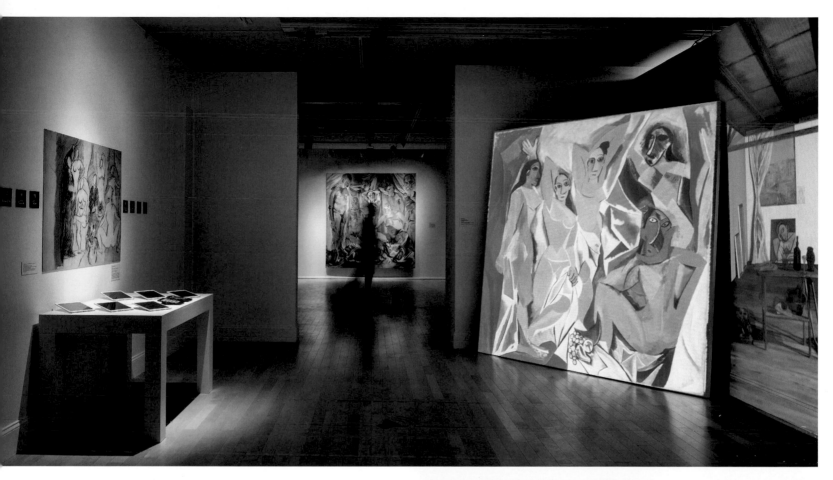

ABOVE: View of the north side of the gallery, with (left to right) reproduction of early study for *Demoiselles* and iPads to access Picasso's figure studies through augmented reality; Geri Davis's painting *Bordel*; and life-size projection of *Demoiselles*. Sound icon on floor indicates listening spot for *The Picture Was an Outrage*, by Jenn Karson.

RIGHT: iPad with augmented reality software shows early composition study for *Demoiselles* (*Sailor and Five Nudes*, May, 1907, Charcoal on Paper, 18¾ x 25⅝"), triggered by the projected painting.

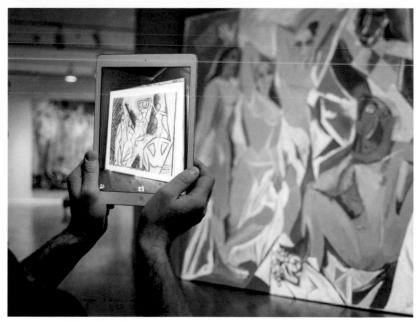

Photographs by Jim Westphalen

11

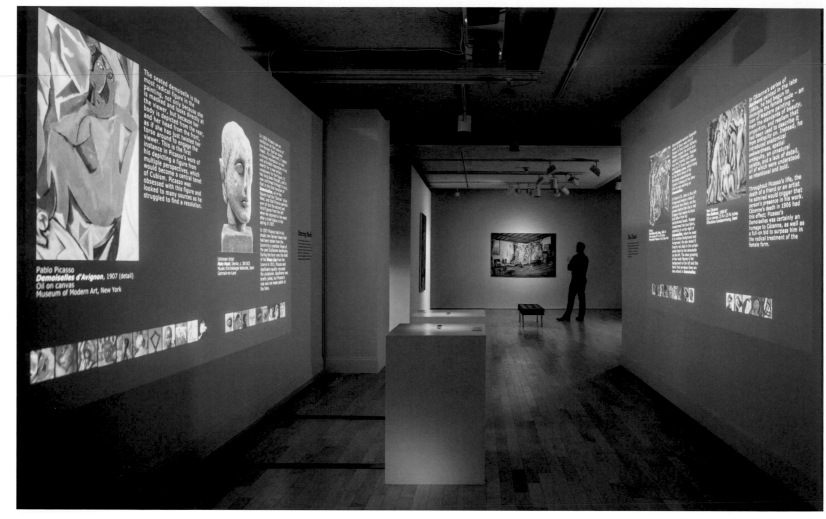

Photograph by Jim Westphalen

Scrolling, projected images and text, with Leap Motion Controllers
Written by Janie Cohen, installation by Coberlin Brownell

Images and text explicate Picasso's motivation for making the painting, and the vast array of historical and contemporary sources that inspired it. Information is presented in sections titled *The Gauntlet*, *The Chain*, *Staring Back*, and *The Twisted Figure*. The two Leap Motion Controllers on pedestals in the center of the gallery space allow viewers to pause the scrolling images and text, or to jump to other selections from the thumbnail images along the bottom, by pointing a finger.

between 1904 and 1911, Olivier is a recognizable figure from his Blue Period, Rose Period, and African Period, as well as in his Cubist work.

The Picture Was an Outrage, Karson's second installation, is heard in an adjacent room by viewers as they stand before a life-size projection of *Demoiselles.* This recording was made in collaboration with members of the UVM and Burlington arts communities, an extension of Karson's own socially engaged art practices. What emerges as subject matter in this piece is the active role that conversation plays in the development of an artist's ideas, as well as evaluation of the artist's later impact. Staging the voices of seven members from Picasso's inner circle, this sound installation presents snippets of personal responses to *Demoiselles* when it was first seen, in his studio in 1907. We hear the documented words of Picasso's contemporaries such as Matisse, Georges Braque, André Derain and Alice Derain; writers and critics Gertrude Stein and Gelett Burgess; as well as the art dealer David-Henry Kahnweiler. The overwhelmingly negative sentiments captured by this sound installation point to the general consensus that Picasso may have gone mad while creating the work, which was initially deemed by his colleagues as a horrendous affront to painting.

The Picture Was an Outrage takes its power by representing a plausible moment of failure for Picasso. The harsh comments captured from over a century ago have a haunting effect, as the very first observations of this painting are reawakened. Criticism bounces through the room on a hypersonic speaker, which carries a strong psychological presence. The experience of sound feels almost as if it emerged from the viewer's subconscious. Building a new dimension of physicality into our collective experience of *Demoiselles,* Karson casts a spell. She confronts Picasso's greatest moment of vulnerability using staged role-play. Upon hearing the voices, one cannot help but reflect on the insults launched at contemporary artists who have arrived at ideas that are not accepted within the art world today.

COBERLIN BROWNELL

Demoiselles is represented in this installation as an electronic image, projected on an 8' by 7' 8" raw canvas leaning against a wall, to scale with the painted original. Viewers are invited to explore the projection, as well as a wall-mounted reproduction of an early study for the painting, using augmented reality, through the lens of available iPads, or the visitor's own smartphone. Using a platform that he designed in custom software, Brownell takes viewers into a navigation of

Picasso's nearly 800 preparatory drawings, capturing the seemingly endless poses, viewpoints, and configurations that Picasso considered while constructing the final painting, including the male figures he eventually removed. The simulated painting, and each of its five figures, trigger content that didactically illustrates its compositional history. Through an excavation of the 2D picture plane, Picasso's hundreds of studies for the painting are disclosed, and, essentially, reframe our perspective on the 1907 composition.

In his reconstruction of Picasso's studio process, Brownell illuminates a narrative that is specific to the exhibition. Viewers are seduced haptically, as the search for more intimate views of the painting are controlled through bodily movement and careful positioning of the iPad's camera. We are lured by the *information* of marks on paper or brushstrokes on canvas, rather than the sensuality of three-dimensional pigments and textures. The viewer's real-time technological gaze generates a trail of 'smart' screen-based images, which unfold improvisationally.

As an additional part of the installation, Brownell has built a virtual representation of Picasso's studio using the 3D modeling program Maya. This imagery, projected on a wall adjacent to the *Demoiselle* "canvas," appropriates Damian Elwes's painting *Picasso's Studio at the Bateau Lavoir, 1908*, which appears elsewhere in the exhibition. Elwes's and Brownell's floor-to-ceiling rendering of the studio interior includes other works that are now familiar from Picasso's canon. They are eerily lit, evoking Picasso's habit of painting at night. Passage of time is implied by a shifting light source, as if the artist himself is moving through the studio holding an oil lamp. At regularly timed intervals, the projection completely darkens, emphasizing its presence as a theatrical backdrop for Picasso's creation of *Demoiselles*. A slight rotation in viewpoint, left to right, can also be observed in this virtual setting, a conceptual nod to the era's great revolution in thought surrounding picture-making, specifically the psychological construction of a modern viewpoint.

Rounding out the exhibition is *Picasso at 23*, a film short by Brownell and Karson that marks the duo's first collaboration. This silent composition is based on a vintage photo of the artist standing outside *Le Bateau Lavoir*, three years before he painted *Demoiselles*. Their idea for this work grew out of a shared sense of dislocation and time travel while researching Picasso's life in *Le Bateau Lavoir*. Projected at small scale, the portrait of Picasso is reminiscent of experimental movies from the early cinematic era, such as the fifty-second actualités created by the Lumière brothers in Paris. Its technique, however, relies on the contemporary rendering of 2D virtual space, and utilizes green screens, Photoshop, and After Effects; it was inspired by stereoscopes, wigglegrams, and animated GIFs. Initially conceptualized as an avatar for Picasso, the subject

of this work shifts from a historical image of the young artist, to a contemporary UVM engineering student whose gaze shifts coolly across the screen: a basic gesture of his awareness beyond the photograph's frame. Intercut are shots that pan the front of the dilapidated *Bateau Lavoir*.

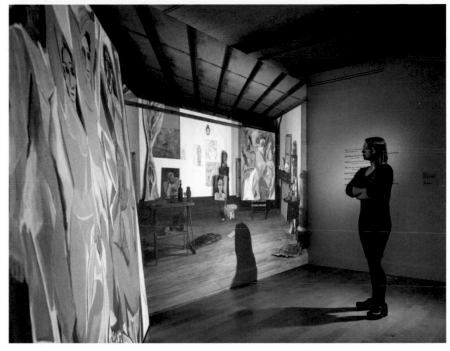

Photograph by Jim Westphalen

On left, projection of *Demoiselles*; on right, video projection, *Picasso's Studio*, by Coberlin Brownell

CONCLUSION

When Fleming Director Janie Cohen organized *Staring Back*, she carefully considered Picasso's role in the avant-garde. His work marked a huge disruption, as well as an homage to the artistic canons preceding him. She describes that tension in his practice in the projected texts, "The Gauntlet" and "The Chain." The radical conceptualism in Cubism's approach to the picture plane represented a threat to the conventions of art in 1907. Yet, what essentially ties an artist's ideas to the greater trajectories of history is "The Chain," which was Picasso's term, much later in life, for how works of art enter into direct dialogue with one another, over time. Like a puzzle, the presence of these conscious influences is detectable to a trained eye, but all of it means nothing without a continual push toward the new and present moment, which is given center stage in the exhibition.

Karson and Brownell are indeed pushing the boundaries of art in a world that moves at a steadily increasing pace. Not only do these artists embrace contemporary tools of spatial representation, they also activate the viewer's participation. They challenge art to engage our senses unconventionally, and ask the viewer to think formally about what lies beyond the picture plane. For museumgoers, this experience can be liberating, confusing, and awe-inspiring. As conceptual artists, Karson and Brownell have looked back on *Demoiselles* as a muse, and, in response, they have returned its gaze and thrown a new gauntlet into the ring. Headed into the front lines of an arts and technology movement, whose story is yet to unfold, they are not staring back at all, but urging us to advance.

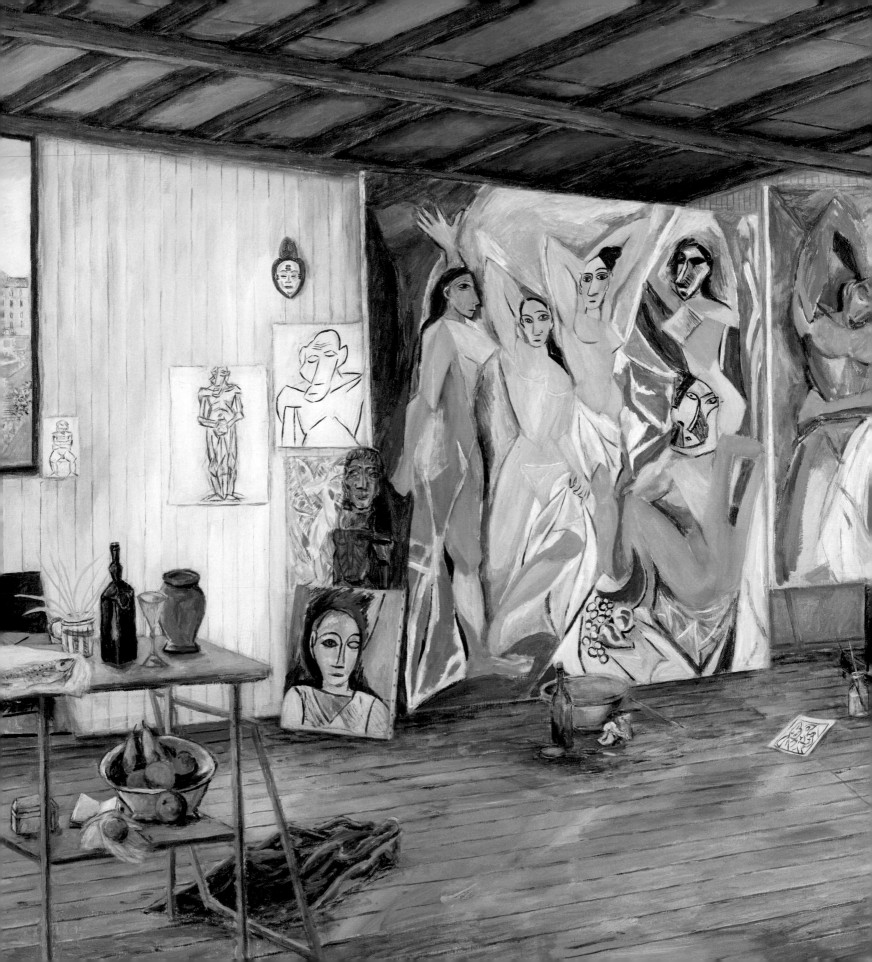

From Paris to New York: The Life of the Demoiselles

BY BETH S. GERSH-NEŠIĆ

L'art, c'est la pierre un jour jaillie

D'un bloc de feu

Qui ne tombe jamais, qui jamais se fixe, froide et qui s'irradie,

Si tu crois la saisir au compas de tes yeux.

Alors tes yeux seront la pierre

Froide jusqu'à ce que d'autres yeux

La saisissent pour mieux prolonger l'infini de sa course.

– André Salmon, *Peindre* (1919).[1]

In 1907, five hideous nude women graced the surface of an 8' by 7' 8" canvas that leaned against a wall in a dark, dank studio in Montmartre.[2] The neighborhood was sleazy, the interiors overrun with rats and lice; we might expect this gang of whores to look with cool disinterest on those who frequented this slum. Hatched from the macho mind of Spanish artist Pablo Picasso, these pink angular female bodies loomed out of the shadows in the basement of the *"Bateau Lavoir,"* at 13 Rue Ravignan; thirty years later, with a few stops in between, they took up permanent residence at 11 West 53rd Street in Manhattan, bristling anew with *sangfroid.* Intimidating, enigmatic *provocatrices,* they preside over the Museum of Modern Art's pristine white gallery walls with their aloof disdain, surrounded by earlier versions of themselves that only enhance their art historical pedigree.

Coy *Mona Lisas* they are not. Confident, they stand and stride into confrontation. Strong of face and character, they may seem less bizarre to our eyes these days—no tattoos, no

Left:

Damian Elwes (British)
Picasso's Studio at the Bateau Lavoir, 1908 (detail), 2008
Oil on canvas. Collection of the artist

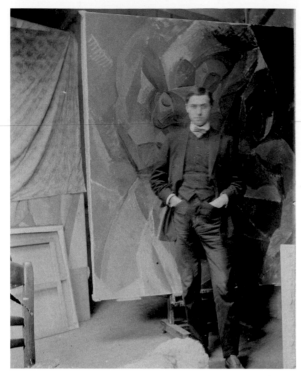

Portrait of André Salmon in front of Picasso's *Three Women* in the *Bateau Lavoir* studio. Photo: René-Gabriel Ojéda. Musée Picasso. © RMN-Grand Palais / Art Resource, NY.

creatively shaved heads, no pierced body parts that belong to the "demoiselles" of our generation. Nevertheless, they still manage to discomfit on contact when we enter their gallery at MoMA. Still fierce at 108 years old, they are the inscrutable, inexhaustible *Demoiselles d'Avignon*: once dissed by the cognoscenti in a decrepit Parisian studio and now revered as "the cornerstone of Modern Art."

"Against the wall was an enormous picture, a strange picture of light and dark colors, that is all I can say, of a group, an enormous group and next to it another in a sort of a red brown, of three women, square and posturing, all of it rather frightening."

- Gertrude Stein, *The Autobiography of Alice B. Toklas (1933)*[3]

Most of Picasso's friends and colleagues found the canvas unspeakably ugly—at best, a studio prank or a moment of "madness" beyond the pale.[4] These uncharitable responses sent the canvas "underground," as Picasso's *Philosophical Brothel* (the original title for the work)[5] ceased to be visible even inside the studio, evident in two 1908 photographs taken in the *Bateau Lavoir*.

In one, André Salmon, the well-known poet, critic, and member of the infamous Picasso Gang, posed in front of Picasso's *Three Women* (1908). He was twenty-six years old at the time, three weeks older than Picasso. Immediately behind Salmon, the *Demoiselles* peeks out from under a large, floral cloth, leaning against the wall next to the newer 1908 canvas, *Three Women*, still on its easel. In another 1908 photograph, we see only the floral cloth behind the head of Fernande Olivier, Picasso's mistress, who holds on her lap little Dolly, the daughter of the painter Kees van Dongen, a Fauve artist who lived in the same building. Based on this evidence, it seems that those who claimed to have seen the work had to have asked the artist to retrieve and uncover the painting for a special viewing. It would have taken some effort, exerted for a chosen few.

Among those who bothered to study the work at length, only André Salmon decided to capture its general appearance in a full (albeit inaccurate) description, mistakenly citing six figures instead of five. He recorded what he remembered in his "Anecdotal History of Cubism," the second chapter of *La Jeune Peinture française* (1912). Here, Salmon recognized something of enormous importance in Picasso's young career, noting the role this painting played in the development of Cubism as it had emerged and evolved by 1912. Salmon's assessment was clairvoyant.

———————————————

For nine years, Salmon's written record of the *Demoiselles'* existence was all the French public knew of Picasso's giant masterpiece. But Salmon had plans for the painting. He introduced the five damsels into society by way of a wartime exhibition *L'Art Moderne en France*, also known as the *Salon d'Antin*, installed in fashion designer Paul Poiret's Galerie Barbazanges at 126 avenue d'Antin, from July 16 through July 31, 1916.[6] However, the work still operated without a title—and Salmon took care of that too.

Picasso's Gang (the poets Salmon, Max Jacob, and Guillaume Apollinaire) always knew the work referenced a scene in a bordello. Salmon decided to invent a title that would obfuscate this information in order to evade censorship at that time.[7] "Demoiselles" sounded appropriately banal, a common term used to identify a young lady, a single woman, a bridesmaid (*demoiselle d'honneur*), or a salesgirl (*demoiselle de magasin*). "Avignon" suggested a place of ill-repute for those who knew French history.[8] The Gang's love of wordplay and coded witticisms inspired the subterfuge. *Demoiselles d'Avignon* sounded fittingly ironic and indecipherable to all but the initiated few.

The reception was mixed. The critic for *Le Cri de Paris* misremembered dislocated limbs and "eyes wandering negligently above their eyes." [9] Louis Vauxcelles (writing under the pseudonym "Pinturricho") declared that Picasso demonstrated a "profound horror for nature." [10] One collector offered the painter 20,000 French francs for the work. Picasso refused to sell and the painting went back to the studio that he then occupied on the rue Schoelcher in Montparnasse. Eventually he rolled it up and stowed it away, where it remained for the next eight years.

———————————————

Outside of France, audiences in Germany and Switzerland could read Daniel-Henri Kahnweiler's article "Der Kubismus," published in *Die Weissen Blätter* (Zurich and Leipzig), dated September 23, 1916, wherein he described "a strange, large painting with women, curtains and fruit," that remained "unfinished" since spring 1907. As Picasso's dealer in France, exiled during World War I because he was a German citizen, Kahnweiler sought to bolster the significance of Cubism with his text, which was reiterated in his book *Der Weg zum Kubismus*, published in Munich in 1920. He agreed with Salmon that Picasso's as yet unknown work paved the way to Cubism.[11] Unable to see the painting, Kahnweiler trusted his memory, as did Salmon, who could have asked Picasso to unveil the painting. Kahnweiler's and Salmon's minor blunders meant that the *Demoiselles* existed in print as something other than its true self for a very long time.

For the American public, *Les Demoiselles d'Avignon* came to light in a faint black-and-white snapshot that accompanied Gelett Burgess's article "The Wild Men of Paris," written in 1908 and published in *The Architectural Record* in May 1910.[12] Here the ferocious five make their appearance above the caption "Study by Picasso." The out-of-focus photograph registers the flatness of the *Demoiselles* and the cool white incisions articulating the flesh, but of course fails to record the jagged blue shapes that compress figure and ground. At least Burgess informs the reader that there is color: "You ask him if he uses models, and he turns to you a dancing eye. 'Where would I get them?' grins Picasso, as he winks at his ultramarine ogresses." Nevertheless, the mistaken description of color fit the purpose of the article: an introduction to the Parisian Fauve movement, the "Wild Beasts." Therefore, the Americans associated this "Study by Picasso" with the Fauves, alongside works by Henri Matisse, Georges Braque, and André Derain, among others.

All too soon Marcel Duchamp's *Nude Descending a Staircase* (1912) arrived in New York for the infamous Armory Show of 1913, usurping Picasso's influence on the New World, as Duchamp stole the limelight on behalf of Cubism in the eyes of the American press.[13] Meanwhile Picasso's modernist nudes remained closeted on the Boulevard Raspail in yet another of Picasso's studios.

In 1916, the famous couturier and collector of African art Jacques Doucet expressed an interest in the *Demoiselles* with the urging of the Surrealist writer André Breton. However,

a meeting of minds and price did not occur until 1924, when the sale was completed for 25,000 French francs (about $1000 at the time).[14] Now the *Demoiselles* stepped out of the shadows and into a shiny brass frame floating across from an enamel and glass Art Deco vestibule on the Doucets' second floor, flanking a studio and an "Oriental Room." On display in this private setting, the demoiselles reflected the lavish modernity and chic exoticism of their surroundings, becoming trophy possessions for a society sultan (and a much regretted decision for the artist).[15] By 1925, the *Demoiselles* went public again in the form of a published photograph (black and white without commentary) placed in the July 15th issue of *La Révolution surréaliste*.[16] In this context, the association proved to be advantageous, as the *Demoiselles* now basked in the Surrealists' libidinal light.

Jacques Doucet died four years later, on October 30, 1929, and Madame Doucet sold the *Demoiselles* through Galerie Seligman to the Museum of Modern Art for 150,000 francs ($28,000) in September 1937. The girls had finally made it: commanding a high-class price, achieving international acclaim, and receiving art history's approbation.

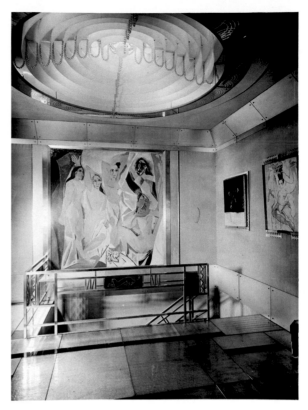

Unknown photographer, French, 20th century. Vestibule, Studio Saint James, Neuilly-sur-Seine, ca. 1930. Virginia Museum of Fine Arts, Richmond, Sydney and Frances Lewis Endowment Fund. Digital photo: Travis Fullerton © Virginia Museum of Fine Arts. © 2015 Estate of Pablo Picasso/Artists Rights Society (ARS), New York

And yet, the maids of Avignon still send shockwaves down our spines. While the anxiety triggered by their relentless aggression may dissipate in front of commercial copies, Instagram posts, or inaccurate textbook reproductions, in person, *Les Demoiselles d'Avignon* feels visceral, not cerebral. Neither fully Cubist nor Surrealist, the painting belongs to no art movement other than its own, perpetually feeding new artists with its generative force, as the exhibition *Staring Back* persuasively demonstrates.

In *Staring Back*, we experience the *Demoiselles* virtually, past, and present, from Picasso's early sketches to its re-interpretation by contemporary artists from Africa, Eastern and Western Europe, and the United States. Here we learn about the painting's rich heritage of artistic sources, and the radiance of its light released from art's block of fire. The painting illuminates each artist's mind differently, and, in return, each artist brightens the work's light uniquely, pushing it further along its boundless path toward future generations.

Peindre!

C'est plus que voir,

Peindre

C'est concevoir.[17]

This essay is dedicated to Professor Jacqueline Gojard, Department of Literature, University of Paris, Sorbonne III, who has been my colleague and mentor in all things Salmoniennes. Her scholarship has guided my work and for that I am always grateful. And I thank Francis Naumann, who invited me to write the catalogue essays for his exhibition *Demoiselles Revisited* (New York: Francis Naumann Fine Art, 2007).

[1] "Art is a stone thrown one day/From a block of fire/Which never falls, never stops, cold; and it radiates/If you believe you grasp it with the astuteness of your eyes./Then your eyes will be the stone/Cold until other eyes/Grasp it the better to prolong the boundlessness of its path." André Salmon, *Peindre* (Paris: Editions de la Sirène, 1919), p. 14.

[2] Max Jacob, "Fox," (1931), *Les Lettres françaises* (Paris), no. 1051 (October 22-28, 1964), pp. 1, 11. Reprinted in *La Nouvelle Critique* (Paris), no. 64 (May 1979), pp. 47-49. Cited in Judith Cousins and Hélène Seckel, "Chronology of *Les Demoiselles d'Avignon*, 1907-1939," in *Les Demoiselles d'Avignon* (New York: Museum of Modern Art, 1994), p.148, footnote 1: "Picasso 'had rented one of the dark rooms beneath the floor of the shack'."

[3] Gertrude Stein, *The Autobiography of Alice B. Toklas* (New York: Vintage, 1961; originally Harcourt Brace, 1933), pp. 20-21. According to Hélène Seckel in "Anthology," *Les Demoiselles d'Avignon* (New York: Museum of Modern Art, 1994), p. 253, Gertrude Stein's book *Picasso* (Paris: Fleury, 1938) was the first book in French to include a reproduction of the *Demoiselles*.

[4] Kahnweiler reported in "Der Kubismus" that Derain thought the painting was a "dead-end" and Picasso would be found hanging next to it (a reference to Émile Zola's famous novel *L'Oeuvre* (1886) – translated as *The Masterpiece* – wherein the artist Claude Lantier strives for recognition in the Salon only to receive ridicule. He commits suicide by hanging himself from his scaffold); reference in Seckel, p. 234.

[5] Considered the original unofficial title for the work, which Salmon claimed a "friend" invented (he, Apollinaire, and Jacob were the collective source): *La Jeune Peinture française* (Paris: Meissen, 1912), p. 44.

[6] The painting is listed in the catalogue as number 129 out of 166.

[7] I would like to thank Jacqueline Gojard for bringing this to my attention in her unpublished essay on Salmon's *La Jeune Peinture francaise* (Fall 2014).

[8] William Rubin, "The Genesis of *Les Demoiselles d'Avignon*," *Les Demoiselles d'Avignon* (New York: Museum of Modern Art, 1994), pp. 17-19.

[9] Anonymous, "Lettres et Art," *Le Cri de Paris*, vol. 20, no. 1008 (July 23, 1916), p. 10.

[10] "Pinturrichio" [Louis Vauxcelles], "Le Carnet des ateliers," *Carnet de la semaine*, August 6, 1916, p. 8.

[11] Daniel-Henri Kahnweiler, *Der Weg zum Kubism* [The Rise of Cubism] (Munich: Delphin, 1920). Both Salmon and Kahnweiler believed Picasso's late 1906 studies mark the transition from the Rose Period to Picasso's *Demoiselles*/African Period.

[12] Frank Burgess, "The Wild Men of Paris," *Architectural Record*, v. 27, no. 1 (May 1910): 400-414.

[13] There were 8 Picasso works in the Armory show: 6 paintings, 1 drawing, and 1 bronze sculpture.

[14] Picasso recorded the sale as 30,000 French francs, Cousins and Seckel, op cit., p. 171.

[15] John Richardson, *A Life of Picasso: The Triumphant Years, 1917-1932* (New York: Knopf, 2007), pp. 243-45; Picasso never accepted Doucet's invitations to see the work. My thanks to Janie Cohen for remembering this fact.

[16] *La Revolution surréaliste*, v. 1, no. 4 (July 15, 1925): 7 (reproduction only). Jeanine Warnod, *Washboat Days*, translated by Carol Green, (New York: Orion Press, 1972), p. 124. André Salmon described the *Demoiselles* as "surréaliste" in his *Propos d'Atelier* (Édition G. Crès, 1922), p. 180.

[17] André Salmon, *Peindre*, p. 36 : "To paint !/Is more than seeing,/To paint/Is conceiving."

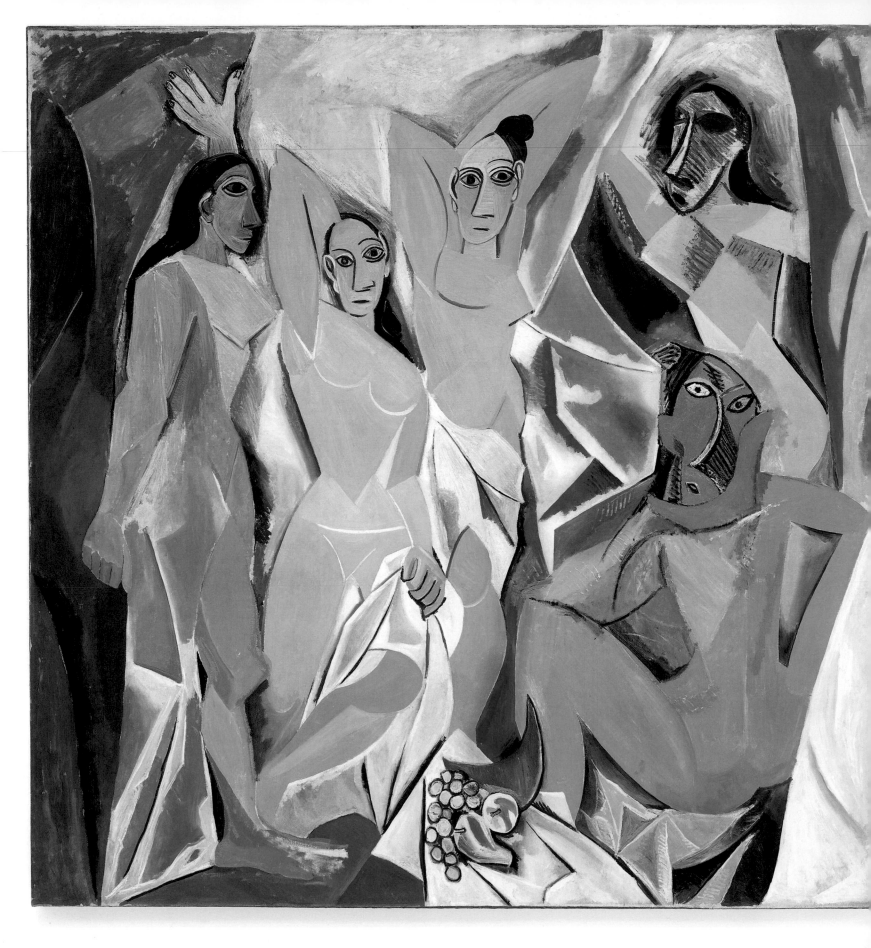

The African Body and Picasso's Demoiselles

[FICTIONAL REMIX]

BY JANIE COHEN

We have long known that Picasso found inspiration for *Les Demoiselles d'Avignon* in the history of art—from Iberian, African, Oceanic, and Egyptian art to Baroque painting, to the work of Ingres, Manet, Cezanne, Gauguin, and others—synthesizing and transforming vastly diverse sources to create a radically new artistic vocabulary. While each source played a role, African art forms are most clearly evident in *Demoiselles*. An often-repeated element of the painting's "creation story" is Picasso's first visit to the ethnographic museum at the Trocadéro Palace in Paris during the spring or summer of 1907, where he was struck by the visual and psychic power of African and Oceanic artifacts. Having made hundreds of studies for the painting in the preceding months, at some point that spring he placed on the canvas five prostitutes in a brothel setting. He initially painted all five figures in the style of the two facing forward in the center of the painting, referred to as the "Iberian" demoiselles; they were influenced by ancient Iberian sculpture, with which Picasso, as an Andulusian, closely identified. Dissatisfied, he took a break from the painting. He returned to it in June or July of 1907, in what is referred to in the literature as his "second campaign" on the canvas—an appropriately militaristic metaphor in light of his struggle with the painting, and with the demons that plagued him that summer. He would later refer to the work as his first "exorcism" painting.

In a recently published article in *Photography and Culture* (vol.8, no.1, March 2015), I make the argument that it was not just African masks and sculpture at the Trocadéro that inspired the "Africanization" of the painting, but also a disturbing subgenre of colonial photography: staged, exploitative images of groups of nude African women taken by colonial officers, commercial

photographers, ethnographers, and others, which were circulating throughout Europe at the time, as postcards, in illustrated books and journals, and as photographs. The racism and objectification inherent in these "anthropometric-style" images make them difficult to look at. The primary motive for the fiction piece that follows was a point in my research when the fear, anger, shame, dignity, and defiance that clings to the photographic record of many of the encounters between African women and European photographers made my academic perspective feel uncomfortable and inadequate. I wanted to look at this invidious power dynamic from the viewpoint of its subjects. At the same time, I wanted to explore what lay beyond historical record on the other side of the equation: how Picasso might have engaged such photographs. This of course made it necessary to inhabit the colonial mindset, adding another layer of challenge to this project. My hope is that a fictional framework may help readers to enter the material on an emotional level, and to better understand this exploitative photographic practice, as well as Picasso's relationship to visual sources, which could be equally callous.

Whatever experiences fueled Picasso's personal and artistic needs and revelations that spring and summer—be it his break-up with his lover Fernande Olivier, his morbid fear of syphilis, African sculpture encountered at the Trocadéro, colonial photographs, Manet's *Olympia* and Ingres's *Grande Odalisque* exhibited side-by-side at the Louvre (both nudes gazing brazenly at the viewer), news of colonial abuses in the Belgian Congo still reverberating from the previous year, African women performing at Les Folies Bergère or on exhibit in "Native Villages," or other visual stimuli and life experiences—his alterations to the canvas radically transformed the painting. He masked three of the demoiselles, introducing Africa into the painting. By wrenching the pose of the seated figure on the right so that her head spun around to face us, he dramatically altered the dynamic of the composition, placing the power of the gaze within the painting.

If, as I believe, anthropometric-style photographs indeed played a role in the development of *Demoiselles*, it further grounds the painting in the colonial context of its time. I also argue, however, that anti-colonialism was the last thing on Picasso's mind as he searched for a solution to his intractable painting in the summer of 1907. He sought only to advance his art. I believe he found in this photographic genre a timely and unnerving visual source that helped him to achieve his goal.

Massawa, Eritrea, August, 1885

I am telling this story so the truth might be known about this picture of us. I will tell everything that happened, exactly as it was.

My friend Jamila, the photographer's madama, came looking for me this morning to tell me that Mr. Naretti wanted us at his studio at noon today. On the walk from Church on Sunday, she had said that he wanted to make a photograph of me and some of the other girls, and she instructed me to round up Rahel, Kibra, and Faruz, and two girls who work in the camps, Makda and Liya. I pressed J but if she knew his intention she did not let on. Jamila's padrone has been making photographs in town for a few months now and they say he pays some people to stand for him. She tells me that sometimes he travels long distances to take pictures, with hired hands to carry his equipment for him.

We met at the square before noon, four madame and two sciarmutte. The girls asked me what the photographer wanted of us, but I was not able to tell them. F was suspicious, the others were excited. M was worried, she is still young and that is her character. I tried to reassure her that I would look out for her. We all admired the clothes each had chosen for the photograph, that is except F, who wore her plain clothes and would have none of it. We then walked a dusty half hour to the photography studio following the directions that Jamila had drawn for me, talking little, mostly wondering what we would find.

When we arrived at Mr. Naretti's studio, we were met by a short, Tigre man who greeted us kindly and led us into a small room. The room was almost empty, with just some chairs and a short staircase that led nowhere except to a fancy column at the top, as if you had arrived somewhere. There were some shades hanging on the walls, some were plain and some had painting on them.

It was hot and we were anxious, I fanned myself to stay calm. We talked quietly from time to time among ourselves but mostly waited in silence. The photographer Naretti finally emerged from the back room. He spoke to us in Tigrinya that came from Jamila—I had to think of my troubles in order not to laugh. He talked about the importance of using the scientific style and looked at us as though we should agree with him about that. We didn't know what he was speaking of. His eyes grew sharp and he looked at us all up and down, and told me, F, and R to leave our necklaces on, and then ordered us all to remove our clothes and to not take any time about it. With that, he turned and stepped back into the other room, closing the door behind him. You could hear the voices of people outside and not a breath

inside. We all looked at each other but there were no words to say. M started to cry. I removed my heavy silver necklace and placed it around her neck so that it might protect her body from the camera. I folded her in my arms for a moment, and with my eyes closed, I turned my shame to fury. We then did as he had said. When he came back into the room he was carrying some beaded necklaces, which he held out to L and K and to me.

Mr. Naretti told me to stand on the top step of the short stairs leading nowhere, facing forward, and L on the middle step and M on the lower step facing each other. We did so. There was hardly any room, but I was glad to have them both close to me. Mr. Naretti acted as though he did not know me, that he didn't see Jamila and me heading to the market arm in arm most days. He told me to put my right hand on L's shoulder. L is a tough one who moved into town from the highlands last year to work in the camps. She looks out for little M. She told me she prefers to be a sciarmutte because they move more freely in the world than a madama, who must answer to her padrone—like a wife, she said, but not honored like a wife. The photographer then ordered R to stand to the side and in front of K, facing away. Finally, he pointed to F and M to sit on the lowest step.

Mr. Naretti then put his cloth over his head to attend to his camera. After a few moments, I saw that M had crossed her hands on her legs in front of her. I held my breath waiting for a reprimand, but it didn't come. Then L placed her hands to protect her modesty from the camera, and R did the same. I looked at K who was staring hard at the ground. She suddenly shifted her leg and raised her hand to her thigh, hiding her belly from the camera. I wondered if the others have noticed what L and I know. K's afraid she'll lose her padrone and end up back in the camps. We waited anxiously for the photographer to say something. I could see F's anger rising in her spine. She had said this morning that if he was going to take something from us we should get money in return. She hadn't been fooled or flattered by the idea of the photograph. I swear on my Bible to all who read these words, I never dreamed this disgrace. Then Mr. Naretti told me and F and M to look at the camera and all of us to stay completely still until he stopped counting. I saw L look up, searching for K's eyes, but they were not there for her. I raised my eyes, God knows, against my will, and then we were captured, just exactly like that.

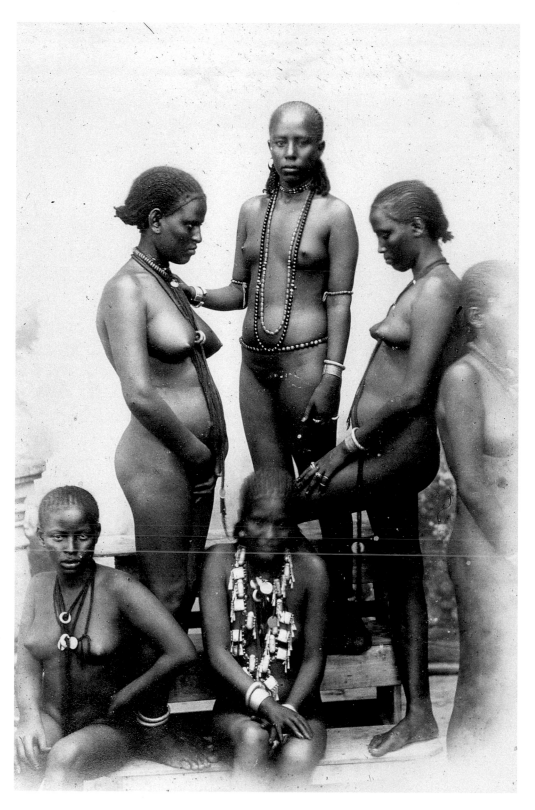

Luigi Naretti, *Eritrean Prostitutes*, ca. 1885

Picasso left the café after the third cuffing to his head. The Gang had had it with his constant distraction. It was Apollinaire this time, and P knew that they knew exactly what was going on. There was little that held him these days other than the five amazons on the large canvas in the studio. He looked at his friends across the table and saw only the demoiselles staring back at him. He had agreed to go with Derain to visit the native villages in the Bois de Vincennes the next day but now he wanted only to stay put in the studio, as excruciating as it had become.

Earlier in the evening, they had been talking about the villages and the natives hired to live in them, or to pretend to. He remembered them vividly from the Exposition when he had first arrived in Paris seven years earlier. Max Jacob had seen them at the fair in Marseille last summer and one night had run into one of the Africans in a bar in the Vieux Port wearing a suit, with a bowler and a cigar. They all laughed at his story. P wondered which had been the masquerade.

With the Exposition Coloniale in Paris that summer, the topic of Africans was taken up again at many café tables around the city. Picasso had more interest in it than in most of the talk he encountered when he ventured out to find reprieve from his battles in the studio. Van Dongen regaled them with stories about the performances he had seen in Paris in the years before Picasso had arrived: the wild dancing of the Dahomey Amazons—the women warriors in the Franco-Dahomean Wars of the 1890s. Picasso knew they had been camped out near the Eiffel Tower for three months during their shows in Paris, just a few years after France had emerged triumphant. He wished he had seen them. He remembered pictures of a large group of Africans in elaborate outfits. But it was the photographs of a few of the women that had stayed with him, naked except for their skirts and their cowrie bangles, and always arranged symmetrically—some facing forward, some in profile, some squatting in front on short stools with their chins resting on their hands. He remembered them as strong, fearless, with no expression. No smile, no shame. Thinking back he remembered being attracted and repulsed at the same time.

As P wended his way back through Montmartre, his thoughts returned to the chilly afternoon early that spring when he had visited the ethnographic museum in the Trocadéro for the first time. It was the same pull, he wanted to leave but couldn't. It was overwhelming: the silent gazes of the sculptures and the masks, the density, the dust, the feeling of suffocation. He had been drawn back numerous times since. And the dinner at Matisse's last fall, he still felt in his fingers the smooth surface of the heavy wood sculpture from the Congo that was handed to him after dinner. He had held it for hours, with no desire to let it go. There was something in these objects he had never felt in his own work, or in his friends'. This had a different purpose and he wanted it for his own. This was pure power, he thought, protection of the spirit, and it lay as much in intention as in form. Picasso thought back to the photographs of the Dahomey women. They had been haunting him since he'd first seen them, and he knew they were haunting *Demoiselles*. He wished he had one of them in his own photograph collection. He remembered having met a friend of Apollinaire who was collecting erotic photographs coming out of the African colonies. He'd find him in the next few days and take a look.

Gérard received him with a hug and a pound on the back, just in time for *l'heure verte*. He handed Picasso a glass and they settled in for a smoke. P told him about the photographs he had recently acquired, some from Egypt and West Africa, including a group of new Fortier photographs taken in Dakar that he was excited to have gotten hold of. When the absinthe was gone and the cigarettes snuffed out, Gérard excused himself and returned shortly with a dark red leather album. He handed it to Picasso with a smile and retreated into the interior of the apartment. A few pages in, P knew his instincts had been right. He found himself staring at two photographs of the Amazons, just as he had recalled them. It was the symmetry he remembered. He found it surprising, not at all picturesque or exotic as he would have expected, but really quite rational. It made for a strong and unusual image. They reminded him of the sculptures at the Trocadéro, all those figures lined up so rigidly, staring at him.

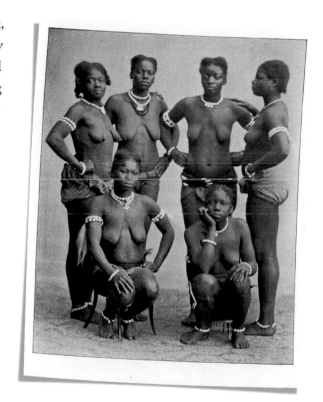

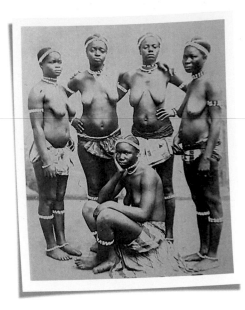

Picasso traced his finger over the photographs. He noticed that in both, a couple of the women laid a hand on another's shoulder, but there was no other interaction among them. All of the gazes tracked directly from them to him; it felt so immediate to him, so real. He thought of the two infamous nudes hanging together in the Louvre since the winter: Manet's favorite model Victorine posing as a Parisian prostitute with her cat and a black maid, titled *Olympia*, as if that would make it more palatable for the high hats; and Ingres's sensuously languid concubine—*Grande Odalisque*. Both had a cool, detached gaze and both had caused great *scandale* among the Salon bourgeoisie many decades before. He was beginning to see where he had to go with *Demoiselles*. He knew he was on to something completely new here: the rigid, stylized poses, the compressed space, multiple sets of eyes staring back. And how much more powerful in a painting he thought. His eyes scanned the two photographs. The hand, he had remembered that too. He saw that in both of the images one of the seated women rested her chin in her hand. It was an unlikely pose—informal, natural. But they were doing it in both pictures. He was transfixed. He wondered if the women had taken the pose spontaneously, or if they had been told to, noting that the other women in the photographs clearly had been directed where and how to stand.

Several pages later, Picasso came to a photograph of four women that intrigued him. The one standing on the left was wearing a knit cap right off the streets of Paris in the winter. And the seated woman on the right reminded him of Asi, the old Moor he used to pass in the half-light of the brothel he frequented in the Barri Xina his last years in Barcelona. He felt them penetrate his world in an uncanny and uncomfortable way. Their expressions were different from the cool, detached Dahomies, P thought, these women did not want to do this. He noticed with interest that the seated women each had her chin resting in her right hand and her left hand in her lap. He laughed aloud, imagining the photographer barking, "You two in front, rest your chin in your

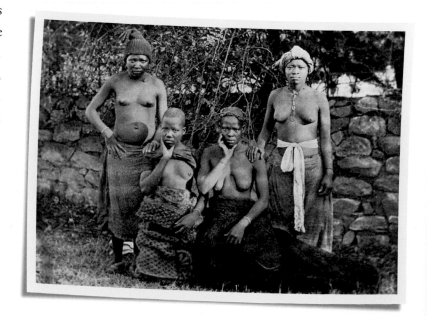

right hand." That, and "put your left hands in your laps, and you two, standing—rest your hand on the shoulder of the one in front of you. Good, now don't move."

He turned the page and paused. Here was one that stopped him cold. He studied the photograph—six African women, nude—in a composition similar to the Dahomey performers, and, he noticed with a shock of recognition, to Cézanne's *Bathers*, and to his own *bordel* back at the studio. Nymphs, bathers, Dahomey Amazons, prostitutes, it's all the same, he thought, nude women together. He only then saw the title of the photograph: *Eritrean Prostitutes*, taken by an Italian in one of their colonies he had heard described. He felt the nausea rise; it always accompanied the unbidden thoughts of syphilis that plagued him, taunted him these harsh nights back in the brothels since he and Fernande split. He stared hard at each figure, thinking about the five prostitutes on his large canvas. The two Iberian girls in the center of his painting stared out with no smile, no expression to speak of. That was a beginning, but he wanted to go

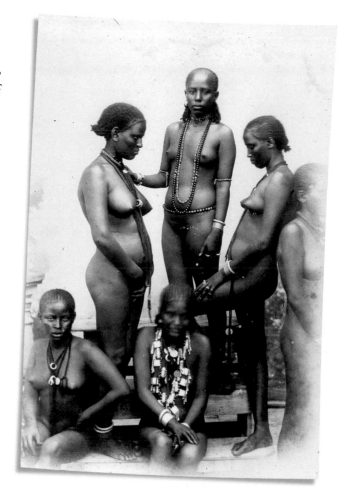

beyond that. This, he thought—the one seated on the far left, looking at him now with the *mirada fuerte*. He knew the stare, knew it could possess and destroy because he used it that way himself. Her hand was on her hip in an angle that reminded him of the Kota sculpture he had seen at the Trocadéro. He ached for her to be in front of him in the flesh. In a moment of comprehension, he saw where he had to take the painting. He felt that familiar rush of heat course through his body and he knew that this time, it would carry him as far as he needed to go.

P took in the whole photograph again, while the storehouse of pictures he carried within raced through his mind. He thought of the demoiselle on the left in his painting, and the one seated on the right: like a print reversal of the Eritrean prostitutes on the far left and right of the photograph before him. He remembered how Cézanne had played with the poses of his bathers from painting to painting, switching the forward leg of the bather on the left from one version to another, and changing the seated

bather on the right from a frontal pose to a rear view. Picasso had done the same, working out the demoiselles' postures in his own sketchbooks over the past months. The figures took on lives of their own, he thought: entering and reentering stage left, facing him and then coyly turning away, or facing away and then turning around to confront him.

He noticed then that the woman on the far right of the photograph had moved during the exposure, her nude body blurred in a way that made it look draped. He imagined her in motion leaving the scene. Those accidents of photography had captured him from the beginning. He knew what the medium meant for painting and that he had to find a way to outwit it; he'd been playing with double exposures and motion in his own photographs since shortly after arriving in Paris, struggling to see what it could tell him about depicting motion on the canvas. He realized with a smile that it was as if his own demoiselle entering on the left had continued moving across the painting. Her shoulder had been draped since her earliest appearances in his sketchbooks last winter. Now he wanted to go back in and strengthen it up a little more.

His focus shifted from the figures to the photograph's tone: the ocher, bitumen, sepia, it reminded him of the under-painting in the old academies. The year before, he had been drawn to the dull rose tone in the Egyptian photographs in his collection and had used it in some of his paintings. He wanted to be careful with color now, to make this painting hard and rigorous where

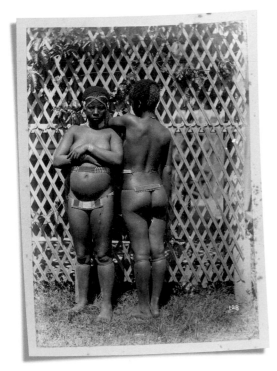

Matisse's success of the year before—*Le Bonheur de Vivre*—was all lush color and languid lines. He noticed that the women's breasts and limbs in the photograph gave the composition an angularity, almost a geometric aspect. This was another world from the pictures he had seen of solicitous Parisian prostitutes in the brothels of Pigalle, he thought, all curves and come-on smiles—brazen, but seductive.

He quickly paged through the rest of the album. The gallery of nudes included poses clearly inspired by European paintings. How perfect, he thought, it goes both ways. But there were many, he noticed, that held those rigid scientific postures, almost like a kouros, or Egyptian art. Toward the end of the album he found a few more that struck him. One was labeled "Young Zulu Women." They affirmed his own obsession with drawing the poses from all angles, trying to capture multiple perspectives in one view. "Exactly," he said out loud.

Picasso turned back to the Eritreans and took one last, piercing look at the seated girl on the left, whose eyes met his with equal force from another place and time. He recognized the pattern of the burning gaze: the photographer and the subject, the artist and the model, the client and the prostitute, the collector and the photograph, and soon, he thought, the painting and the public. Now the power would reside in the painting. He would show them all up, his friends, his competitors, his critics and enemies.

He closed the album, bid a hearty thanks to Gérard and made his farewell, setting out through the warm night back to Montmartre. Passing Lapin, he heard the song of drunken camaraderie but did not pause, even for a moment. Before descending the dark stairway leading to the studio, he stopped to look out on the lights above the city, which were softened now by years of grime on the small window. He knew, as surely as he had known anything, that he had found his intercessors. In their gazes lay the power and protection he needed. He opened the door, staring through the dark studio to the faces on the canvas, envisioning exactly what was to come.

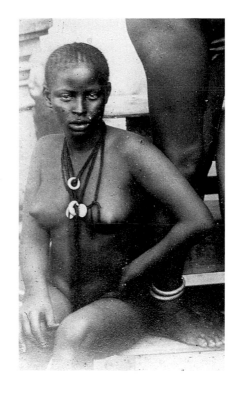

IMAGES

Page 29: Attributed to Luigi Naretti, *Prostitutes, Eritrea*, ca. 1885, albumen print. Courtesy Nicolas Monti / Monas Hierogliphica, Milan.

Page 30: *Pablo Picasso at Montmartre, place de Ravignan*, about 1904. Inv. DP 7. Photo: RMN-J.Faujour. ©RMN-Grand Palais/ Art Resource, NY.

Page 31: Carl Günther, *Six Ashanti Women* ("Dahomey Amazons"), Berlin, 1893. Location unknown. C. H. Stratz, Die Rassenschönheit des Weibes (Stuttgart: Verlag von Ferdinand Enke, 1903), 127, figure 64.

Page 32: (Top) Unattributed, *Bodyguard of the King of Dahomey, International exhibition*, Hamburg, 1890. Location unknown.

Page 32: (Bottom) Unattributed, *Female Types of the Botswana of the Orange River Colony*, Prior to 1910. Location unknown. Albert Friedenthal, *Das Weib im Leben der Völker*, 2 Vols., (Berlin: Verlagsanstalt für Litteratur und Kunst, 1910), 281 fig. 446.

Page 33: Attributed to Luigi Naretti, *Prostitutes, Eritrea*, ca. 1885, albumen print. Courtesy Nicolas Monti / Monas Hierogliphica, Milan.

Page 34: Unattributed, *Two Young Zulu Women*, 1870-1900. Albumen print adhered to card stock. Visual Resource Archive, Arts of Africa, Oceania and the Americas, (VRA.1989.34.28), Image copyright ©The Metropolitan Museum of Art, Image source: Art Resource, NY.

Page 35: Attributed to Luigi Naretti, *Prostitutes, Eritrea* (detail), ca. 1885, albumen print. Courtesy Nicolas Monti / Monas Hierogliphica, Milan.

Demoiselles *as Muse*

BY JANIE COHEN AND BETH S. GERSH-NEŠIĆ

Contemporary artists respond to this still-potent masterpiece in terms of its current position as a great milestone of modernism—something that must be engaged. Their works reflect its shift from obscurity to veneration, from reviled painting to invaluable masterpiece. For some, *Demoiselles* is a philosopher's stone of "Artistic Truth" still rife with mystical clues; for others, it calls out for correctives. These artists teach us about *Demoiselles'* place in our contemporary culture, our so-called "Postmodernist" world that critiques, decodes, and deconstructs with impunity. Like *Demoiselles* itself, their work confronts our gaze with a variety of styles and perspectives, seeking, among other things, the unacknowledged humanity locked among the abstracted forms.

LEONCE RAPHAEL AGBODJÉLOU (Beninese)
***Untitled (Demoiselles de Porto Novo)*, 2012**
C-Print
59 x 39 in.
Courtesy of Jack Bell Gallery, London

Leonce-Raphael Agbodjélou, a renowned African photographer who exhibits in London, re-situates *Demoiselles* in the context of French colonialist art in a series of portraits entitled *Les Demoiselles de Porto Novo*. Son of celebrated photographer Joseph Moise Agbodjélou (1912-2000), an artist who belonged to the generation dominated by Picasso, Leonce Raphael establishes his own voice in an ongoing portraiture project featuring the people of his hometown Porto Novo, the capital of Benin and the former French Dahomey. The women portrayed in the series from outlying villages are traditionally bare-breasted; their faces are concealed by ceremonial masks that introduce the spiritual realm of Vodun. The setting for the series is the artist's home, a colonial mansion commissioned by his grandfather who made his fortune selling lemonade to the Portuguese and French armies that controlled the Afro-Brazilian slave trade under colonial rule. The house was built in 1890 in the colonial style by Afro-Brazilian artisans who were among those repatriated to Porto Novo.

Agbodjélou creates an image that speaks to historical and contemporary economic, cultural, and religious contexts. By borrowing the visual references and the title of Picasso's *Demoiselles*, the artist reclaims "Picasso's Africa" for Benin—the site of one of the French colonies through which Picasso's awareness of Africa was filtered at the beginning of the 20th century.

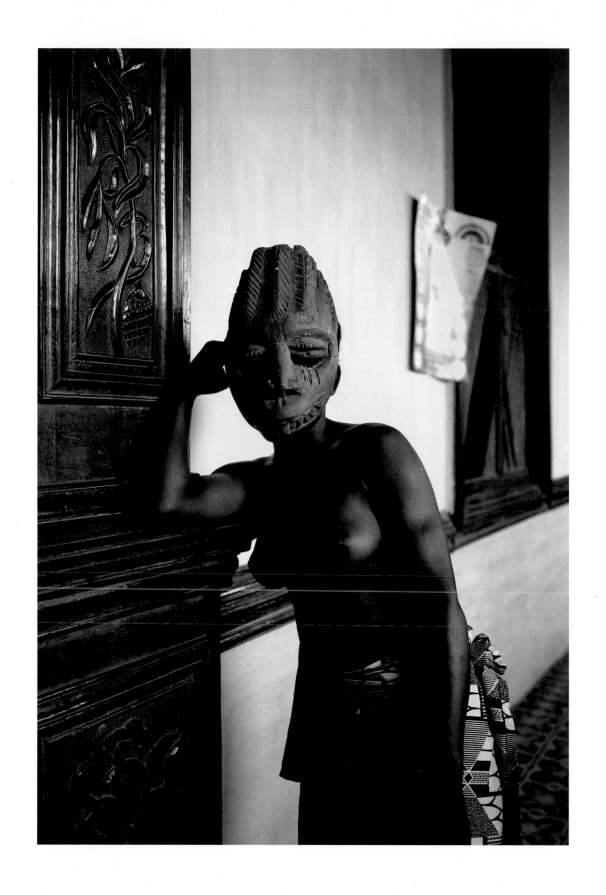

GEORGE BIDDLE (American, 1885-1973)
Europa, 1926
Lithograph. Edition of 100
Sheet: 11 ¼ x 16 ¹⁄₁₆ in.
Stone: 7 ³⁄₁₆ x 11 ¹³⁄₁₆ in.
Courtesy of the Museum of Fine Arts, Boston, gift of L. Aaron Lebowich, 50.360
Photograph © 2015 Museum of Fine Arts, Boston

George Biddle (1884-1973) was an American artist with a law degree from Harvard, who studied art in Paris at the Académie Julian in 1911 and the Philadelphia Academy of Art in 1913 and 1914. He returned to Europe in 1914 to study art in Munich and Madrid. After serving in World War I, he settled in France in 1924. In 1928, he travelled to Mexico to work with artist Diego Rivera.

In this lithograph from 1926, Biddle presents an unusual representation of the myth of the abduction of Europa by Zeus in the form of a white bull. Usually represented simply by Europa and the bull, Biddle depicts five nude women with a sixth in the background, whose postures echo those of Picasso's demoiselles. It is possible that Biddle saw Picasso's *Demoiselles d'Avignon* in American Gelett Burgess's article in *The Architectural Record* in 1910, in André Salmon's exhibition in 1916, or in *La révolution surréaliste* in 1925, all of which were accessible to him before he made the print *Europa.* Biddle's print served as the starting point for artist Stas Orlovski's engagement with *Demoiselles* (see pp. 52-53).

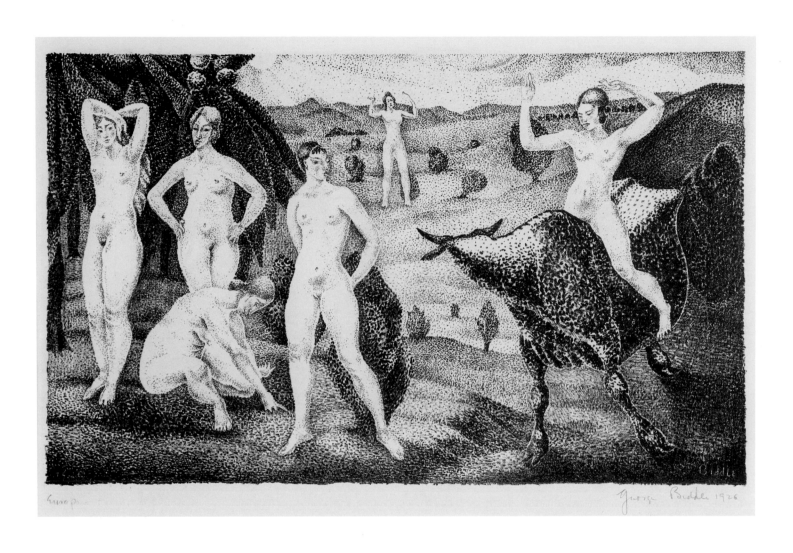

Europa George Bidder 1926

GERRI DAVIS (American)
Bordel, 2010
Oil on linen
96 x 92 in.
Collection of the artist, New York, NY

In her painting practice, Gerri Davis merges disparate perspectives to create vertiginous compositions involving the body. Davis has long been drawn to Picasso's *Demoiselles* on multiple levels. Her metaphorical male *Bordel* disarms the historical Picasso persona, rendering him listless and impotent. Yet for all the transgressive iconography, the colors remain luscious, incandescent, and sexy; there is energy in the light that ascends from the forms. About the painting, Davis writes,

> *The* Demoiselles d'Avignon *marked a turning point when paintings ceased to be thought of as windows that we look through, and began to be seen as planes that we look at. When I began my life as a painter, Picasso's pivotal piece was a point of entry into the discourse of contemporary painting. I studied his work by interacting with it as a painter, by painting it. I wanted to engage his interplay of iconography and abstraction, where figure and void exchange places and symbols assume statures according to their importance. He exposed his inner demons for us in his petite bordel, exposing the disdain he felt for his own desire. Here the elder Pablo is stripped bare, his wares on display above a labia-like shellfish garden. It is ultimately an exorcism of venerated misogyny by a young woman more historically suited to be the muse than the painter – it's as if the puppet has stepped out of the proscenium and taken hold of the strings.*[1]

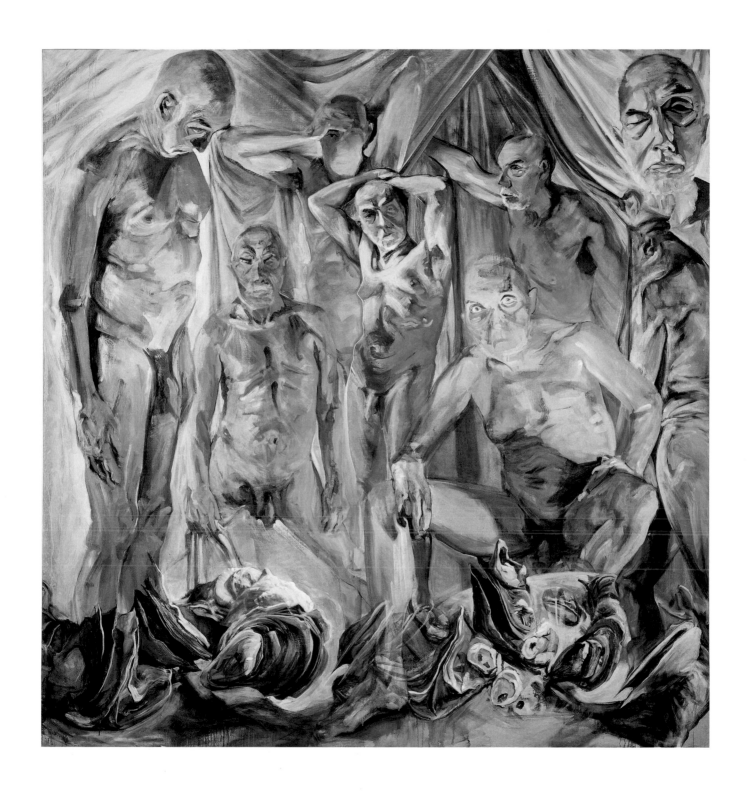

DAMIAN ELWES (British)
***Picasso's Studio at the Bateau Lavoir, 1908,* 2008**
Oil on canvas
48 x 72 in.
Collection of the artist

Between 2002 and 2008, Damian Elwes painted his *Artists' Studio* series in which he recreated Modernist artists' studios based on photographic, textual, and architectural documentation, aided by his imagination. The series includes paintings of Picasso's studio at nine different points in his life, from 1908 to 1956. Elwes was so drawn by the 1908 iteration that he made five paintings of it, each differing slightly in content and perspective. The painting depicts *Demoiselles* and Picasso's 1908 painting *Three Women* in his studio, surrounded by related work by the artist. Elwes explains that the cloth under the table refers to the fallen red cloth in El Greco's *The Vision of St. John,* which was a strong influence on *Demoiselles,* as well as to another referent,

> *There is only one existing photo of* Les Demoiselles d'Avignon *in Picasso's* Bateau Lavoir *studio, and it shows that the top half of the painting was sometimes covered by a cloth. This was presumably done because the masked faces caused too many unwanted reactions. In my painting, I have removed the cloth which is lying on the floor. . . . In a sense, I am appropriating* Les Demoiselles d'Avignon *and all the other artwork in the painting, but I never thought of it in those terms. . . . My paintings are about creativity. I never try to paint an exact replica of any of these masterpieces because that would be dull. Instead, I try to leave their paintings unfinished because that makes them lively and different from the images that we know so well. I started painting studios at the beginning of my career as a way to learn from artists, and it is still the case that I learn so much from each studio painting.*[2]

Elwes recontextualizes well-known works by re-placing them in their original contexts. He opens the door to understanding an artwork in terms of its life in the studio, the fruit of both the artist's labors and the numerous influences that accumulate through the years.

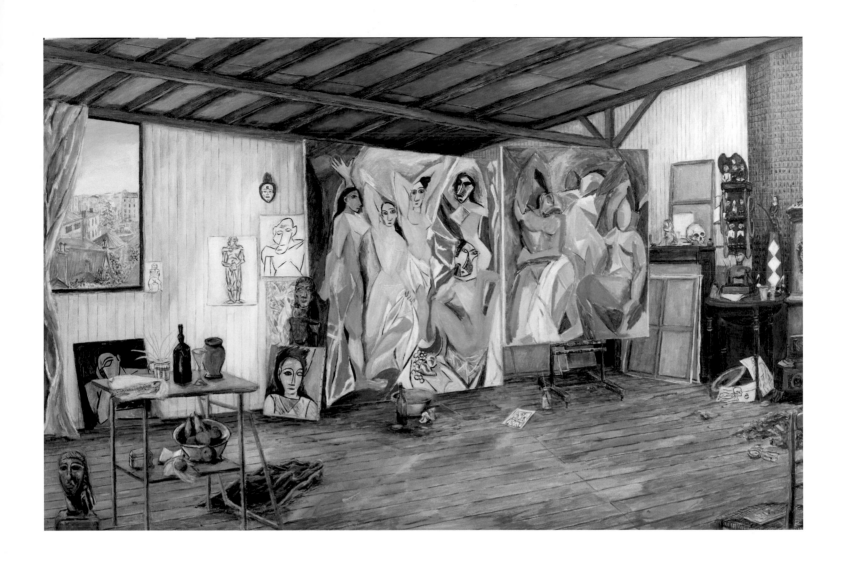

JULIEN FRIEDLER (Belgian)
La Demoiselles d'Avignon (three), 2007
Bronze
Each 7 x 7 ¾ x 4 in.
Courtesy of the artist and Gabrielle Bryers Fine Art & Production, LLC

Julien Friedler began his career with degrees in philosophy at the Sorbonne in Paris and ethnography at the Free University of Brussels. He then studied psychoanalysis in Paris, following the post-structuralist theories of famed psychoanalyst Jacques Lacan, while also undergoing psychoanalysis with him. In the 1990s he established an institute in Brussels to promote an interdisciplinary approach to psychoanalysis, but he left the field when it proved impossible to break through the constraints of the classical approach.

Entirely self-taught, Friedler began his artistic career in 1994. His work confronts postmodern contemporary society and reflects insight into the human character gained during his career in psychoanalysis. The work exhibited here in triplicate presents one figure, with an obscene gesture and the *vagina dentata* found in various folktales, that embodies and extends the overall attitude, bearing, and implicit threat of the fiercest of Picasso's demoiselles.

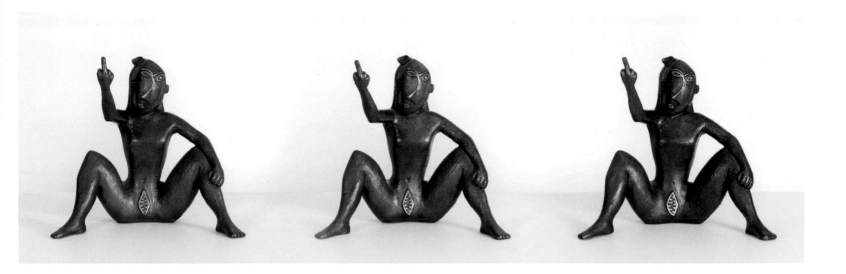

KATHLEEN GILJE (American)
Demoiselles, 2007
Oil on linen
64 x 39 ½ in.
Courtesy of the artist

A former painting conservator, Kathleen Gilje has redirected her technical skills in order to modify the images of masterworks, creating what she refers to as "contemporary restorations." She has produced riffs on artists from Raphael and Jan van Eyck to Manet and Picasso, with alterations ranging from disrobing 48 of Sargent's society women, to inserting members of the New York art scene into celebrated historical portraits.

In Gilje's *Demoiselles,* she takes on Picasso's two demoiselles on the far right of his painting, substituting two curvaceous contemporary women, one with a tattoo on her lower back. Gilje chooses to make her female figures robustly Realist in the Courbet sense of the term, and utterly self-possessed in their poses and womanliness, transporting us back to the reality of models in the studio. Whereas Picasso radically broke the "fourth wall" with his demoiselles looking directly and accusingly at us, Gilje has restored the women to their private world, lost in their own thoughts and not the least bit concerned with ours.

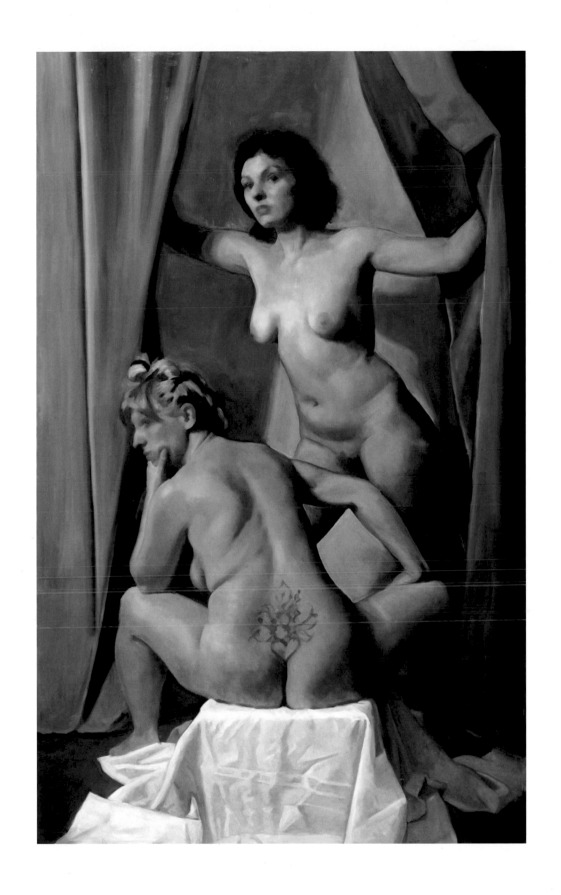

CARLO MARIA MARIANI (Italian)
Untitled, 2007
Watercolor, pencil, wash, and collage on paper
22 x 22 in.
Collection of Liz and Scott Evans, NYC

Like Picasso, Carlo Maria Mariani looks to the past in his work, quoting masterworks of antiquity and frequently juxtaposing them with elements of contemporary life. The work exhibited here, like several others in this exhibition, was created on the occasion of the 100th anniversary of *Les Demoiselle d'Avignon*.[3] It juxtaposes Picasso's second demoiselle with Jean-Auguste-Dominique Ingres's study for his painting *La Source*, created between 1820 and 1856 and certainly one of Picasso's many sources for this figure. The tension between the two evokes a frisson of disorientation, as Ingres's traditional classical beauty, rounded and sensuous, competes with the cartoonish modernism of Picasso's flat and crisply outlined demoiselle. This is Mariani's mission: to reinvigorate modern art through classical/academic allusions. His side-by-side arrangement underscores the artistic act of "staring back," which Picasso had referred to as "the Chain," the transmission of visual traditions from one artist to another through the ages. Françoise Gilot described Picasso and Matisse in their later years agreeing that it was "important for an artist to remain alive in the mind of another artist and to a certain extent in that artist's oeuvre." Mariani and other artists in this exhibition continue that tradition.

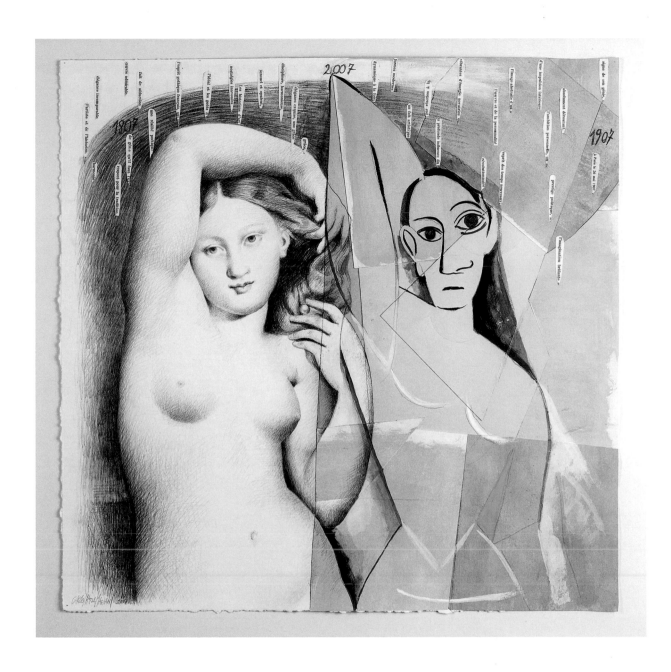

SOPHIE MATISSE (American)
***De-Moiselles,* 2007**
Oil on canvas
47 x 45 in.
Collection of Mr. and Mrs. Harvey Blau
Courtesy Sophie Matisse © 2015 Artists Rights Society (ARS), New York

De-Moiselles belongs to Sophie Matisse's series *Missing Person*, in which she recreates Old Master paintings omitting any figures within. Matisse deletes the iconic bodies, spotlighting the fractured background of Picasso's painting that aggressively competes with the foreground. Some of the areas she has introduced to complete the background echo the forms of the demoiselles' body parts, suggesting an absorption of foreground by background. In this way, her painting spotlights this new, shifting relationship in Picasso's painting, which would become central to the development of Cubism.

Sophie Matisse is the great-granddaughter of Henri Matisse, Picasso's greatest rival during his early years in Paris, and one of his closest friends in later life.

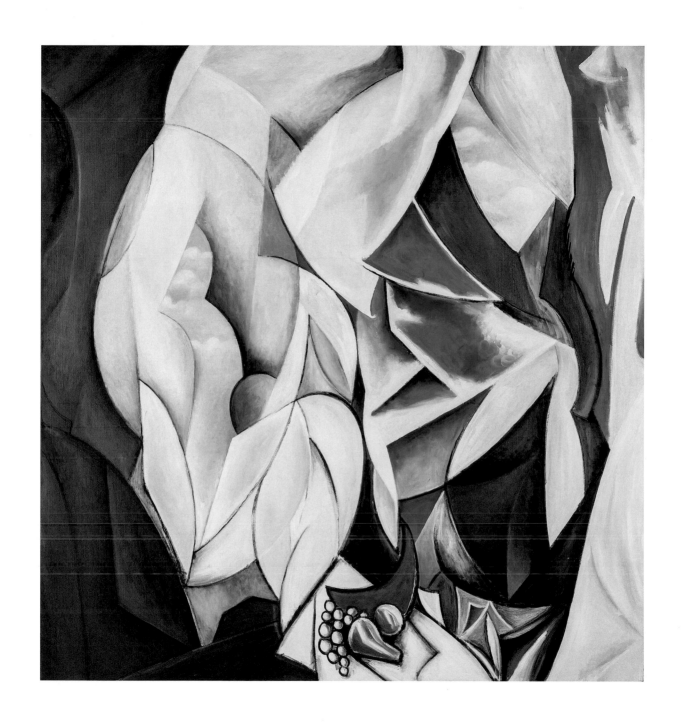

STAS ORLOVSKI (Moldovan)
Figures, 2012
Ink, charcoal, gesso, and Xerox transfer on paper
68 x 31 in.
Courtesy of the artist and Mixed Greens, NYC

Stas Orlovski writes,

It's difficult to avoid Picasso because he shows up everywhere—even in the cubist/suprematist/folk mash-up of my mid-century Russian children's books. . . . I began specifically referencing Picasso's Demoiselles *by way of a lithograph by a lesser-known 20th-century American artist named George Biddle. About 15 years ago a friend gave me a portfolio of various prints that included Biddle's* Europa. *Dated 1926, it depicts 6 stylized nude female figures, one of which is riding a bull, in an imaginary landscape. The iconic poses and bull motif suggested that Biddle was wrestling with his own relationship with Picasso. I was struck by the conversation that was taking place within this modest print.* Europa's *awkward (in a good way) attempt to negotiate the space between figuration, abstraction, allegory, and social realism provided an entry point into Picasso's vocabulary.* [4]

Orlovski returned to Biddle's print over a period of years, finally appropriating some of the figures he associated with *Demoiselles* into his own work, including his animations, in which they have become central characters. This drawing is a product of a stop-motion sequence from Orlovski's first animated project, titled *Nocturnes.*

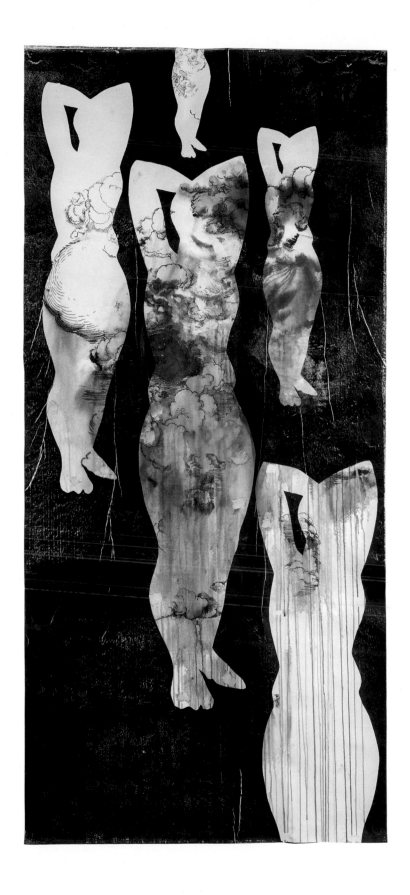

JACKSON TUPPER (American)
Sophie, Diana, 2012
Archival pigment print, diptych
20 x 30 in.
Courtesy of the artist

Jackson Tupper is a recent alumnus of the University of Vermont's studio art department. His work *Sophie, Diana* reflects his long-standing exploration of Picasso's work, evident in its gentle cubist composition and demoiselle-like pose. Consciously or subconsciously, the piece captures the spirit of gender ambiguity in the *Demoiselles*—not exactly as it appears in the original painting, but as an element that transgresses the sanctity of the traditional female figure in art. The image of the Diana camera that occupies the right half of this diptych represents the gaze itself. The juxtaposition of woman and camera speaks to the role of the gaze in the artistic enterprise—a significant theme in the *Demoiselles*. This work is part of a series of portrait diptychs by the artist.

[1] Email, Gerri Davis to Beth Gersh-Nešić, January 10, 2015.

[2] Email, Damian Elwes to Beth Gersh-Nešić, January 11, 2015.

[3] Created for the exhibition *Demoiselles Revisited*, Francis Naumann Fine Art, 2007.

[4] Email, Stas Orlovski to Beth Gersh-Nešić, January 10, 2015.

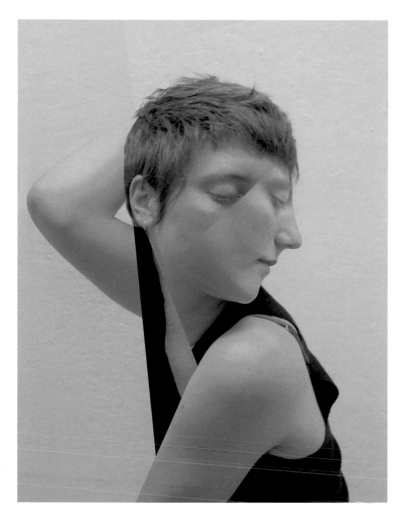 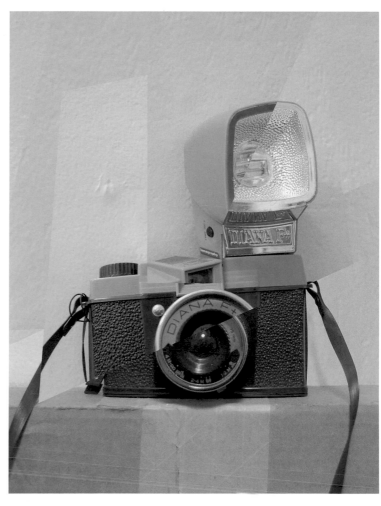

CHECKLIST

Leonce Raphael Agbodjélou (Beninese)
Untitled (Demoiselles de Porto Novo), 2012
C-Print
59 x 39 in.
Courtesy of Jack Bell Gallery, London

George Biddle (American, 1885-1973)
Europa, 1926
Lithograph. Edition of 100
Sheet: 11¼ x 16 1/16 in.
Stone: 7 3/16 x 11 13/16 in.
Courtesy of the Museum of Fine Arts, Boston, gift of L. Aaron Lebowich, 50.360

Coberlin Brownell (American)
Picasso's Studio, 2014/15
3D Environment created in Maya
120 x 146 in.
Thanks to Damian Elwes for the use of his painting, *Picasso's Studio at the Bateau Lavoir, 1908*, 2008

Coberlin Brownell and **Jenn Karson** (American)
Picasso at 23, 2014
Photo: *Pablo Picasso at Montmartre, Place Ravignan*, ca. 1904
Video created in After Effects and Photoshop
20 x 15 in.
Thanks to Andrew Giroux '15, and Alan Mosser, UVM Department of Theatre

Gerri Davis (American)
Bordel, 2010
Oil on linen
96 x 92 in.
Collection of the artist, New York, NY

Damian Elwes (British)
Picasso's Studio at the Bateau Lavoir, 1908, 2008
Oil on canvas
48 x 72 in.
Collection of the artist

Julien Friedler (Belgian)
Les Demoiselles d'Avignon (three), 2007
Bronze
Each 7 x 7¾ x 4 in.
Courtesy of the artist and Gabrielle Bryers Fine Art & Production, LLC

Kathleen Gilje (American)
Demoiselles, 2007
Oil on linen
64 x 39½ in.
Courtesy of the artist

Jenn Karson (American)
Place Ravignan, 2015
Found sounds, Foley, created with Max
Edison Horn, ca. 1907, courtesy of Jenn Karson and Ken Mills
28 x 19 x 19 in.
Thanks to the University of Vermont Fab Lab

Jenn Karson (American)
The Picture Was an Outrage, 2014
Sound recording, Hypersonic sound
Thanks to Joe Egan and Egan Media Productions, the University of Vermont Fab Lab, and participating readers

Carlo Maria Mariani (Italian)
Untitled, 2007
Watercolor, pencil, wash, and collage on paper
22 x 22 in.
Collection of Liz and Scott Evans, NYC

Sophie Matisse (American)
De-Moiselles, 2007
Oil on canvas
47 x 45 in.
Collection of Mr. and Mrs. Harvey Blau

Stas Orlovski (Moldovan)
Figures, 2012
Ink, charcoal, gesso, and Xerox transfer on paper
68 x 31 in.
Courtesy of the artist and Mixed Greens, NYC

Jackson Tupper (American)
Sophie, *Diana*, 2012
Archival Pigment print, diptych
20 x 30 in.
Courtesy of the artist